BLOSSOMS
& BONES

BLOSSOMS & BONES

ON THE LIFE AND WORK OF GEORGIA O'KEEFFE

Christopher Buckley

Vanderbilt University Press
Nashville, 1988

LIBRARY OF CONGRESS
Library of Congress Cataloging-in-Publication Data

Buckley, Christopher, 1948-
 Blossoms & bones : On the life and work of Georgia O'Keeffe / by Christopher
Buckley.
 p. cm.
 ISBN 0-8265-1232-1 (pbk.)
 1. O'Keeffe, Georgia, 1887-1986—Poetry. I. Title. II. Title: Blossoms &
bones.
 PS3552.U339B5 1988
 811'.54—dc 19 88-20691
 CIP

Published in 1988 by Vanderbilt University Press
Printed in the United States of America
Designed by Gary Gore

Acknowledgments

The author and publisher make grateful acknowledgment to the editors of the following periodicals for permission to reprint those poems in this collection that first appeared in their publications:

"From 10 Variations on the Evening Star in Daylight" first appeared in *The Hoboken Terminal* (Vol. 3, No. 3).

"*Two Jimson Weeds*" first appeared in the Winter/Spring 1981 (Vol. 40/41) issue of *Antaeus*.

"Dead Cottonwood Tree, Abiquiu, New Mexico, 1943," "Ranchos Church No. 1," and "Red Hills and the Sun, Lake George" first appeared in the Winter 1988 issue (#26) of *Quarterly West*.

"The New York Paintings," "Palo Duro Canyon," and "59th Street Studio" first appeared in the Spring 1982 issue of *Ontario Review*.

"Summer Days/Ram's Head with Hollyhock," "Light Coming on the Plains," and "Red Poppy" first appeared in *Nimrod* (Vol. 25, No. 1), International Literary Journal published by the Arts & Humanities Council of Tulsa, Oklahoma.

"Lake George With Crows/Black Hollyhock, Blue Larkspur/The Lawrence Tree," "Ladder To The Moon," and "Juan Hamilton's Black & White Photo on the Back of the Penguin Edition of the Paintings" first appeared in *The Chariton Review*.

"Road Past the View" first appeared in the Spring 1982 (Vol. I, No. 2) issue of *The New Jersey Poetry Journal*.

"Ansel Adams' Photo, 'Georgia O'Keeffe and Orville Cox, Canyon de Chelly National Monument 1937' " and "Shell and Old Shingle VII" first appeared in *Hubbub* (Vol. 3, No. 2).

"Black Hills and Cedar," "Red Hills and Bones," "From the White Place," and "East River No. 1" first appeared in the Fall 1988 issue of *Pacific Review*.

"Sky Above Clouds" and "Starlight Night" first appeared in the Winter 1982 (Vol. II, No. 1) issue of *Cumberland Poetry Review*.

"Train in the Desert" first appeared in the Summer 1988 issue of *The Bloomsbury Review*.

"Black Cross, New Mexico," "A Black Bird with Snow-covered Hills/Black Bird Series (in the Patio IX)," and "Pelvis and Moon/Pelvis III/Cow's Skull—Red, White and Blue" first appeared in the Autumn 1984/Spring 1985 (Vol. II, No. 3-4) issue of *Bluefish*.

"Shell I" first appeared in the Winter 1982 (Vol. 90, No. 1) issue of *The Sewanee Review*.

"Philippe Halsman's Photo of Georgia O'Keeffe at Abiquiu, New Mexico, 1948" first appeared in *Helix* (1983, No. 16).

"Black Cross with Stars and Blue" first appeared in *Quarry West* (1983, No. 17).

The author wishes to add special acknowledgments to:

Jon Veinberg for his friendship, patience, and help with these poems.

Nadya Brown for suggestions and help with revisions of the manuscript.

West Chester University for a New Faculty Scholarship Development Award which enabled him to complete this book.

The Poetry Society of America for the 1987 Gertrude B. Claytor Memorial Award for the poem "East River No. 1".

Contents

Preface

This collection of poems is homage, not homily. I am not attempting to speak for Georgia O'Keeffe, nor am I trying to define her work in any absolute academic or aesthetic way. In my opinion, too many have made that mistake over the years.

These poems are written as monologues, and in that sense they do assume O'Keeffe's voice. After many readings of her writings about her work and life, I found this the most natural way to write the poems. It would be going too far to say that O'Keeffe's actual voice, the texture and vision of her life and work, entered my conscious or subconscious mind as I wrote. But I do not think a person can spend a long time looking at her art and thinking about it and not be, to some degree, favorably influenced by how she saw the world, how she phrased her perceptions in art or in words.

Nevertheless, these monologues are poetic device. Simply, the monologue was the clearest and most profitable way for me to enter a painting or photograph and say what Georgia O'Keeffe's work and vision, her world and images have suggested and meant to me.

The titles of the poems in *Blossoms & Bones* derive directly from the titles of O'Keeffe's paintings. Often, two or more paintings are grouped together in a single poem title; in those cases the titles of the individual paintings are separated by a slash (/). The three poems based on photographs of Georgia O'Keeffe carry the photographic titles.

<div align="right">

Christopher Buckley

</div>

BLOSSOMS
& BONES

I

Sky above Clouds

My first memory
is of the brightness of light—
light all around—
a quilt of it, a patchwork
of red and white blossoms on blue
like these clouds down the evening sky,
their form, their budding lines . . .

My mind holds them
stretching away
above the day's cadenza,
that half hour when the hills
glow and lift on a last held note—
it is then that my mind saunters
over the cool, immaculate squares,
over the horizon line,
the next hill, where light flowers
across the finite trellis of this world . . .

Starlight Night

A life like any other on the plains,
and so I grew looking out to starlight
and the unknown, the scintillation
at the far string's end of my imagining.
I wished on the spangled fish and
kites of light and wanted to gather
these worlds the way I felt them there,
fasten them sparkling above the hum
and tug of this blue, blue heavy one.

And so each evening I set my heart
and eye seining among the thinning sky
and painted the budding schools of stars
with their rounded corners and irregular fix—
light has its forms, its violet madder,
but dreams vaguely by until we are pleased
with our own perceptions and see
its pulse backing the random void,
its puzzle locked in all we know.

But someone is always having a say
about how it should look, the wise men
disagreeing about stars and art, my art—
so many bickering crows of thought—
and finally, I am most interested
in what they don't say, because
there can be holes in the hard lines
of thinking, just as there are clear gaps
in this heaven's brilliant display . . .

Red Poppy

I want you to see
what I see of flowers—
the meaning of a word is not
the meaning of a color,
and so this scarlet poppy
doubled and redoubled
with its life,
as flowers are relatively small
and no one has the time,
and seeing takes time.

There is no doubt here;
this effusive flower
draws us with a feeling
as direct as the sun, when,
as a child one bright-hot day,
I held my hand up
to shield my eyes and
saw my fingers glow
red as any flower or star
as the light seeped through them.

There is a dark abstraction
at the heart of it,
an intangible
that only comes clear in paint—
the colors in their lines
are often the most definite form
to say what I mean,

just as where I was born
and how I've lived do not,
when compared to what I've done.
What is of interest
is to love some small thing
and see how it grows within you,
how the petals,
the papery flesh of the flower,
barter with the wind
and carry life outward
as obviously as blood,
and not so unlike us.

Light Coming on the Plains

One long note's level drive
across the wash—we come in
at the crescendo, on the pollen
of light from the first idea
to fill space in a beautiful way.
In the spectrum's short waves
a blue concerto spins
a substance for the eye.

A dot, a water-splash,
and beneath the gas and custard light
something moves in what will be
a plain of amber waves,
a sea dark with breathing cells.

Each day we see the afterglow
singing over the earth's pale edge,
primordial as our blood, blue
and lightly swimming up our arms.

From this I learn the love
of paint as paint—the first life
coming into our eyes we can name
and tell things by, so we can worry
about the clothes we choose,
and how our hair goes grey.

From 10 Variations on the
Evening Star in Daylight
(#s III, IV, V, VI)

I had nothing but to walk into nowhere
and the wide sunset space with the star—
far away from town it was high and bright
in the broad daylight.
 Humming there
in the same key as the sun,
there was at first something prodigal
about it, but soon the sky toned out
and it was rare against the waves of light.

I was face to vast face
with my elements, one primary hand
of color like a fountain pushing up
the star—its yellow filaments
tinting green, the horizon red
and rolling as the day sank off,
and somehow the sea, a long desert blue
in the absence of roads, fences, trees.

Once out here my sister
shot bottles thrown into the air—
now their white chits cannot be
found anywhere on the way home.

At this hour, the world is composed
of but a few basic lines,
and standing upright in the expanse,
I am only one more.

Palo Duro Canyon

Weather seemed to go over it,
wind and snow blew by the slit
in the plains as if it wasn't there.
We descended into that lone, dry place
down the cattle trails at evening;
the hills were sheer and
had a fiery, primeval film.

Even clouds hovered flame bright,
and far to the bottom
red rings of light,
perilous as the very place
Alighieri stood, or the dream
when your bed rises into the air
and you are about to fall . . .

We climbed out on all fours
and against the far sunset ridge
a long line of cattle headed down
like black lace on the canyon edge—
I kept my eye on a small wedge of blue
winging high and away.

Dead Cottonwood Tree, Abiquiu, New Mexico, 1943

The river has moved off somewhere
to sleep, singing to itself underground
past all these chartreuse sprigs and cholla,

and when it wakes must again shoulder
its own green weight in the world through
a distance of greasewood and iron-red hills.

But here, this tree is beyond all that, calm
as any bone or creekstone is calm—clearly
it has little more to do than let the sun

reminisce along this absent architecture
of limbs as they finger the abstract up-swing
of the blue, the watery applications of light.

Stripped down by air, remaindered to nothing
but the wind's thin arms, it's nevertheless turned
to it for solace, taken its wild grey notes to heart.

Train in the Desert—1916, charcoal on paper

And so it comes
shaving away the formless
dark with its dark form,
stripping the silence down
to a smoke of movement
pall mall down the iron
corridor of its two grey lines,
taking over this space
with the half-light
of some big idea
about ourselves,
as if we were sure
that this is progress
we've sent thundering
outward in circles of sound
for our own amazement,
as if we will matter
finally to the sand
and the sky's long view,
that haze traveling
continually about Time,
as if the hand of man
will outlast all this,
the world slipping darkly
off its wheels . . .

II

Summer Days / Ram's Head with Hollyhock

Because at first there were no flowers
I began picking up bones,
a place to begin to have a say.
They had nothing to do with death,
they outlasted it, and here, still
sparely support some long thinking.
We grow by pieces from what's around us;
these leftovers reaffirm our living
in the assonance of the space
they have let go.
 Wind-polished
and stubborn as the hills, the bones
share their distance washed away—
against the cloud-sweep, a skull
is eloquent as a single hollyhock.
Red salvia and sunflower, violet daisy,
were raised by rivulets of wind
and then remembered by red hills,
the very earth ground petal by petal
to powder and mixed to paint them.
A ram's head, a deer's head,
are the final flowers
in relation to the sky,
and please me very much—
they are resplendent
and sing in their own right
like summer days always coming back
to the storm-blue matter of the mind.

Flowers and clouds go up, so much
smoke in the heat, tossed,
chaff as the body is chaff;
and only the shale of bones
offers a reply.
 Still, bones
have something for us;
they come back, shapes in our mind
better than flowers, but flowers
nonetheless—the pure sun-white bloom
we all have in us, living, and after.

Ladder to the Moon

Stopped short on a dark earth
each day, there is more left to do.
Like the ragged peaks of the Pedernal,
I reach and have patience,
the good roof of my will,
against the unvaried clouds of dust.
I take hold of whatever comes along—
horse skull, pelvis, shell—
to say what is to me the shape
of wonder, the wideness of it here.

Half a moon hangs high and white,
blossom or hull beyond your feet?
Always something glimmering above you
and how to touch it to be sure?

You must become fluent with your hands,
make something of the sky's blue-green
nettle, the invisible bones
that get us from heart to mind.
There is a fitness of things, and,
as I see it, a lean body on two good arms,
and tonight this ladder for the moon—
this pure saddle of light floating
down a breath-thin line
as night by sleeping night
you climb out of this life
as sure as you stand here, longing.

Black Cross, New Mexico

Black, a cross blocks out
the blue and ash-like
lift of evening—only
a far dot of moon rises
freely, white and wafer-thin.
And you will come upon
a cross almost anywhere here,
appropriate to these hills
which are as evenly shaped
as souls, edged blue-grey
and bright as embers
while the flat flame
of the horizon holds.

The cross is broad, strong,
driven together by four pegs;
it divides east and west—
on the one hand the dust,
on the other the dark.
Painting it is a way
of painting this country
as I felt it
in its penitent glow—
but burnt or burning,
it's long been too late
to save this land
for anything except
what's left of the light.

Two Jimson Weeds

Self-assured as clouds
they bloom and come on
at evening in the cool.
Beneath the moon
the sweet fragrance
calls you from the house
to take the air
like a sherbet after meals.
Hearts of pale Mars violet,
of light lime green, and
the feeling you could swim in.

Long veins hold the flower
open to look at you,
but I found they are the death
of horses and persist back
through the bones and sand.
Yaquis have some use of them,
another fear half-known.

But I paint these flowers
with nothing more behind them
than sky on rising sky,
equivalent of the sigh I felt—
I have only to think
of their delicate colognes
to feel the coolness
of evening pass over me.

A Black Bird with Snow-covered Hills /
Black Bird Series (In the Patio IX)

I would have it seen
this common feat of a blackbird's flight,
(always there, always going away)
because much is hidden from us
as our heads start to circle
with sleep and the desire in the world,
like these clay-red hills covered with snow
over which the dark birds veer.

Those who lie late in dreams
calling lowly, *let me be,*
wake to this agent of the close-at-hand
when he's an omen on the porch,
their spirit's knife to divide them
breast from wing, bait for the blue.

A crow's riff above the hills
comes back from the cave,
from the mind's one angle—
hard, darted lines
high above the limbs of the cold.

And so I shape what I can,
bend the objective feathers to fit
the abstract and brief term
of beauty, reminding us
of our feet midway in an old road—
this way but once, and we pass.

Black Hills and Cedar

All on their own
 the black hills come up
 and the clouds,
bone-pure, just over them—
 humped, dark as two brick ovens,
then that line of white, like a compromise.

I like it here
 as nothing is completely desolate
unto itself,
 lost as light out here might be
in its charcoal and flesh-full strains
 if no one
rode out to see it.

 Always in this wind-bare gulch,
some small thistle
 will pull blood out.
This cedar bush for instance—
 creviced in
the wash and cutaways
 of the hills' burnt skin,
bottomed-out
 where the sand backs up—
 is just now
flourishing, funneling in the cloud
 and run offs,
shooting out boughs
 the salty green of sea waves
blown back,
 the dappled blooms outdone
only by the distance of the blue.

Ansel Adams' Photo, "Georgia O'Keeffe and Orville Cox, Canyon de Chelly National Monument 1937"

Surrounded by so little
we were unmindful as the clouds
sifting into that long wash,
that slow cut of time, as it sloughed
another of its half-bright skins.
You buttoned your jacket and leaned into the wind,
my pale wrist was a flower there, bent
toward you and the unassuming skies.

And so our plain features
just fell into agreement
with a fading world of clouds—
and behind us, the ghost riders,
our hearts' white horses turning grey.

The West has almost disappeared except
in films where cowboys in black & white
are as humble in their hats as we
before a far and still horizon.

And given these long ropes of clouds,
their knots of loss largely overlooked,
this might well be all of this earth
we'll recall before we're ridden out
on the spare and uncoaxed focus of the light.

III

The New York Paintings

Even now it's like a dream,
the city going up
like tall thin bottles
with fluttering moths of light,
dark even by day as the towers
pinch out the sky and ice-blue
glass centers down their brick.
The grand height of all of it
kept me painting, looking up
to the perfect rise and rub of blocks,
the spangled avenues by night
in a line off toward the stars,
intersections where sky boxed through
with the unexpected sun biting
a piece out of the Shelton,
and sun spots stalling
in the shafts of air.

But this passes in the paint
like dust dissolving red as a stop light,
red as the East River under the burning stacks.
Soon the sounds of traffic and harbor boats
are long and sad as lowing cattle
and finally you feel raw
beneath these high-toned stars,
feel hunted by the buildings
angled over you like hawks.

Lurking on a ridge of clouds and smoke
there's a Billy-the-Kid moon,
and you find yourself turning in the dark
toward the sudden snap of a match
and asking *¿Quien es?*

59th Street Studio

With a northern skylight
and two windows to the south,
with pale lemon walls
and an orange floor,
this loaned space was not
what you dream of for painting.

I chose instead
the room back of the studio,
the narrow window opening
onto a small court—I chose
the beige and light blue of evening
moving through it, the stone-blank
outer walls, the terra rosa
of the sunset and smoke
edging through the glass,
a last white wing
above it all.
 Without bombast
or bright gates thrown open
we should discover our place
subtly, and by degree trim
the dark from the simple medium
our hearts should be, so
the little we have to say or see
resonates, and bears us up.

East River No. 1

Dead of winter and nothing
visible on the opposite bank
but those black stacks towering
their throaty smoke and turning
to frost against the lifeless grey,
the blur and shroud of December.
As far as I can see
this could be the city
of the dead, shades stalled
among some dimmer shades.
Even on the near shore
the ramparts of roaring
industry are stopped, black
and bloodless as the bricks,
as the roads going nowhere fast.

And several stories above it all
I think that if there are two worlds
there is little difference between them
now—the cold thickens everything,
the roots of ice break up the streets,
and no one will be buried today,
no one ferried to the other side.

Confined to my apartment, I manage
with the little glow seeping in
beneath the level of the clouds,
the steam heat and blank length
of room, this time on my hands
and the little life I rub into them
before starting back to work
and looking down the dreary air
to where the smoke's brief light
touches off an ice-white swath
of water, as I take my sweater's
arm and wipe the window clear.

Lake George with Crows / Black Hollyhock, Blue Larkspur / The Lawrence Tree

Summer in Taos.
On a bench beneath the big tree
on the Lawrence ranch,
I'd drift a bit toward sleep,
toward the past in colors—
trunk and branches of the tree
in a heart-tangle
toward whatever's backing stars,
bark and leaves red/black
as hollyhock, the sky blooming
blue as larkspur I found
in an open field nearby.

Overall, the indigo of dream,
and I'd see Lake George, poplars
tall and breathing to maroon hills,
cloud-streak silvered with moon,
and a birch shimmering at the edge—
golden leaves I'd row myself beneath
admiring the many choices
upper branches made for the sky.
Over the cerulean lake, three crows
tilted like dim ideas of myself
as I felt the flower-cool air
in either hand and in my face
and was of three minds,
flying equally off—
do I break for the far beyond,
or fall back slowly
to the bench and grey earth, or
hover a while in between,
dipping wings to the mirror
and calling for the firmament to see
how the powdered light spreads
before the blank dimension of dawn?

Pelvis and Moon / Pelvis III / Cow's Skull—Red, White and Blue

These are what is left for our imagining—
husks we can hold out against the sky
and let our eye sing through for shape
when there's more sky than earth to deal with.
These bones were useful as any heart,
and now, held rightly to the air, are wings
to keep our vision poised.
 You look through
holes to a blue that outlives us all
and see how the white curves keep us.
And below a chalk-dust midday moon,
staring there like any cow skull
you come on face to face, you find
that the light pours through each way.

As the sea comes back here, your hands
turn cold holding these hip bones up;
as the sage in wind laps like waves on a shore,
as some mussels turned a million years to stone
still offer a bit of their original blue,
your arms raise these spirits' staves
shining with use like your own, before they too
are left somewhere dully in a sandy unknown.

From the White Place

Whatever brings us out of this
bottom rock and sun-drowned daze,
out of this hollow gorge,
this boneyard, these broken trails
we walk looking down for stones,
for deadwood, the dying in our way?

I often content myself
with these ivory pillars, this limestone
unfolded and thumbed upwards
by the ghost of lost water,
layered as salts or silts are,
like time calcified, like thick
petals of a calico rose,
like slowed clouds—shimmied up
by wind to where a patch of green
breathes out over the headland's crest.

At dawn or late at evening, the sky
too is white above here, a muslin sheet
calm beyond the turquoise or amethyst air.
I come here to be reminded
from the umber and the gold,
from the land's dramatic gestures
as it breaks itself down,
how pure the palette can finally be—
these few columns, rinsed with sun,
lift me—mountain's husk like chalk,
like snow, like our last words
up this dry waterfall of light.

Road Past the View

From my window
on the expanse,
the road goes out
a silver blue, a vein
dying flame-like for Santa Fe.
It makes a wide smooth sweep
loving the hills, the sand
handwritten with sun.
Past the trees and mesa
which do not count for much
in the eye's long run,
it almost stands up in air
and breaks cleanly
toward the peaks
of the Sangre de Cristo
powdered with that distant
and imagined light.
The road points finally
high and to the left,
some other corner of the earth,
but slides back easily
in the sharp angle of my thought,
saying always its little bit
about roads, how the shape
and direction of things assist
the heart, and are vital signs
by which we reach for what
is just beyond our view.

IV

Shell I

I picked it up in the Yucatán
beached in the undergrowth where
tides rinse themselves of life—
bleached earring of light,
even now when I hold it up
the sea comes back to me
with what we know and don't know.

Each shell is a world in itself
and looking closely from the side
it is impossible to tell
whether it winds inward,
shaded heart-wise toward itself,
or outward spinning off its last
rough flakes of time.

Like this shell resting on dark glass,
like the red coral left on the sand,
what we've touched and taken in,
what calls us back, tells us how,
chamber upon chamber, our years
add their beauty and regret
until our bones break open
and we are salt flowers, star floss,
luminous shapes for wind, outlines
on the narrow isthmus of the soul.

Ranchos Church No. 1

The nave billowing
like the arched
backbone of a cloud,
two L-shaped wings
and the way they sidle
up to air—each dune-
like slope of wall hard
with that dark movement
skirting the evening
mountain's edge as it
persists before the flat
abstraction, the eternal
attrition of that blue.

These forms withstand
the steady re-thinking
of the wind, the old
indifferences of earth.
And somehow this thick
clay supports the heart,
takes us gradually up
level upon level above
the dust, the sky's sand
and streaks of loss.
 And here,
stepping out one day
we might take our place
just outside the anonymous
flags of clouds, the incidents
of our lives then amounting
to little more than the uneven
but sturdy praise of our hands,
these worn but undiminished
aspirations of line to light.

Black Cross with Stars and Blue

The evening gives way
to the gleaming concourse
of other worlds—the near planets
and undistanced stars swim
up the dark and pause.

And looking up,
we secretly call out
to four or five
wishing with an absent mind,
supposing an unfettered drifting off.

But this is a parochial place
where mountains halt
before the azure reach
of sky or thought, where our feet
bring us to conjecture
among the sand and sagging bones
of earth.
 Clearly, this life
is staked to the body and
these dark markers remind us
of all that's driven through
the simple fiber of our desire.

And although we've seen the earth
as one bright mote blown
across the splintery plains of space,
all our stars, and so much blue,
still cross our hearts.

Philippe Halsman's Photo of Georgia O'Keeffe
at Abiquiu, New Mexico, 1948

This is what I have—a ghosted adobe ranch,
ironwood and mesquite, the smoke tree's buds
with their blue apology to heaven—the desert
in its every part saying *loss*, and then
these clouds shaping and reshaping the days
to say that loss and gain are nothing,
that flowers and bone are much the same,
that I'm welcome to whatever I find.

Rivers and an unseen shore, clouds hold over us
that first enigma—the soul's white dust set against
our affinity for form, against the wind, and always
we are asked to step out of our dark coat and hat,
out of the little space that is the very earth,
in our last shirt formless as the flagstone
scattered across this yard, as these clouds thinning
like the end of all desires, and reminding us
that there are things we will never know.

Despite them, I know some small thing—
you choose a place and begin to work;
the sun divides everything into equal parts
and you adjust your eye, your heart,
and, one more piece of this light,
praise these bright, diminished reaches.

Or you come upon a cattle skull, its jaw
a lock of time turned skyward in the old silence—
still, your fingers sidle up to the blind eye and
bad teeth, and with a white scarf about your head,

with the simple language of sand, you start
to understand the dry blossom we are all becoming.

I have a ladder set to my roof from where
I can paint the moon, that dreamer's stone,
bone to bone as resourcefully as the clouds
or jimson weeds, as sparely as the clock of stars.
God, I suppose, leaves us to our own designs
until we too are only remnants of this place.

Red Hills and the Sun, Lake George

Before the birds' aubade
or the milky rose of mist
tips skyward off the surface
of the lake, before you think
to speak, the white center,
the bare bone of light,
loosens itself in aqua
and violet arcs above
the swales and folds
of hills whose wind-cut lines
shrug off the dark in perfect
memory of themselves . . .

I like this first hour,
the glissandi of sunlight
ringing between the sky
and a land whose skin
is the wind-burnt color
of pomegranates flayed
and vibrant in the frost.
And of all there is
this might be enough
to choose from, were we ever
again to say how we'd have
the world, see it made over
in an image all its own.
For now, these hills lift
like hands—implicit
in their praise of nothing
more than earth and air,
and so remind me that
longing and acceptance
are equal parts of prayer.

Shell and Old Shingle VII
(mountain across the lake)

Today, I'm of a different mind,
nothing lives in me
with a bright, hard line,
and what I feel is so faint
that the red day's threads
are washed-out mauve in a cloud
that this grey lake mirrors.
I find I've painted my life,
things happening in my life,
without knowing it until now,
until this view from the window
onto these shells and crusts
floating at my arms' length.

The mountain's a weatherbeaten shingle,
one flap of a heart purely penitent
in this bruised hour, this amethyst light—
I think of doves, of ash,
and the coarse shirts of saints,
of how smoke gives ground and kisses
before it dies skyward, paler
than our life as we are losing it . . .
This is a last blush, the rose of dust
on our cheek and soft upturned palms.
These are the last shades of evening
and in them you want to breathe out
with everything you have
and hold on to the burning.

Red Hills and Bones

No one takes the absence
into account the way I do—
this rind of backbone, the bridge
and scale of its blank articulation,
sustains some perfectly whole
notes of light against the raw
muscle of the land unbound,
the undercurrents surfacing
in concert with the white riffs
of cholla spotting the swales.

Put right, one part of loss
counterpoints the next, leaves us
much to see despite the frank
abrasion of the air. Finally,
this thighbone is every bit
the bright, hard stuff of stars
and against the hills'
rust and clay sets free
a full, long silence here
that as much as anything
sings all my life to me.

Juan Hamilton's Black & White Photo on the Back of the Penguin Edition of the Paintings

Can this be the earth?
I answer directly as the eye serves
tied to the form of things
summer in the mind . . .
My world was not all here before
I shaped it, pared it
subtly as a cloud does,
bringing weather, suggesting to wind,
moving bracelets of sand here,
raising the hills' red hands there,
accepting the world insofar
as a cloud accepts light
passing through it . . .

And so I am here,
available to the distance,
and have settled with the rain
that cuts its place and fires
the saguaro seed to reach
and hold its own, bloom forcefully
for the sun.
 I offer this land
in its hearted shades,
the wearing down of things
against their own life,
that you might see how
the honing, the spareness
of their essential light
is that beauty we are
always looking toward.

The evening calls such a song
after a long walk to a knoll
from which we can see best.
We stand here and prepare,
staring flatly out at a future
where our bones will fall or rise
behind us like any fish or flower
and our souls fly out
like fireflies to the night.
My star-white bolt of hair unwinds
toward the deep rose of space,
its spinning rinds,
and what shells beach up from this
hard-hewn body's shore, say
I made this, lived here, and more.